"Fairfield Porter is a bit of a mild dish, don't you think?" Alice Neel asked me in the late 1970's in her Spanish Harlem apartment studio on 107th Street. Alice, always a bit of a tease, was competitive in an endearing way, and I knew the answer she wanted me to give. I like Fairfield Porter, but I knew what she was aiming at. "Yes, he is a bit, Alice," I replied.

She then went on to show me the portrait she had done in the 1930's of Joe Gould with multi-phalluses protruding from his torso and giggled "Don't you just love it?!"

This moment came to mind when I was asked to say a few words about Cumwizard's paintings. Mild dishes, they are not. Like Neel, the work can be brazen, direct with forthright painthandling. The subject matter can be considered to be "unsavory". Who else has made paintings of Donald Trump? Does this mean Cumwizard admires Donald Trump? Certainly no more than Warhol admired Mao, who proceeded to apply lipstick and mascara to his official face. I appreciate Cumwizard for approaching Trump as a subject, and it was one of the first paintings of his that I acquired. And God knows I *detest* Trump.

Cumwizard is what one would call an outsider artist—self-taught but surprisingly sophisticated in both subject and execution. He is not following any 'trends', and allows a pleasant reprieve from a relentlessly inbred artworld.

— John Cheim

T0035686

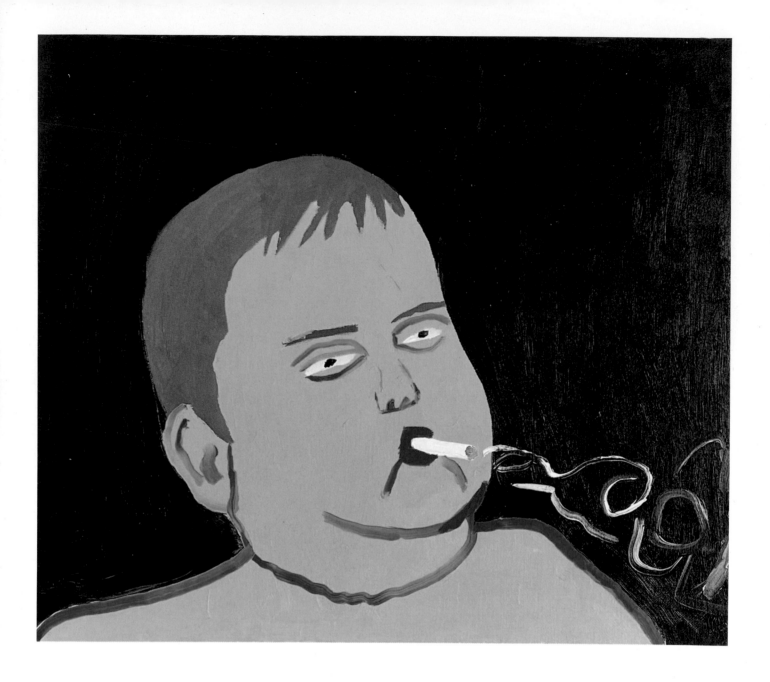

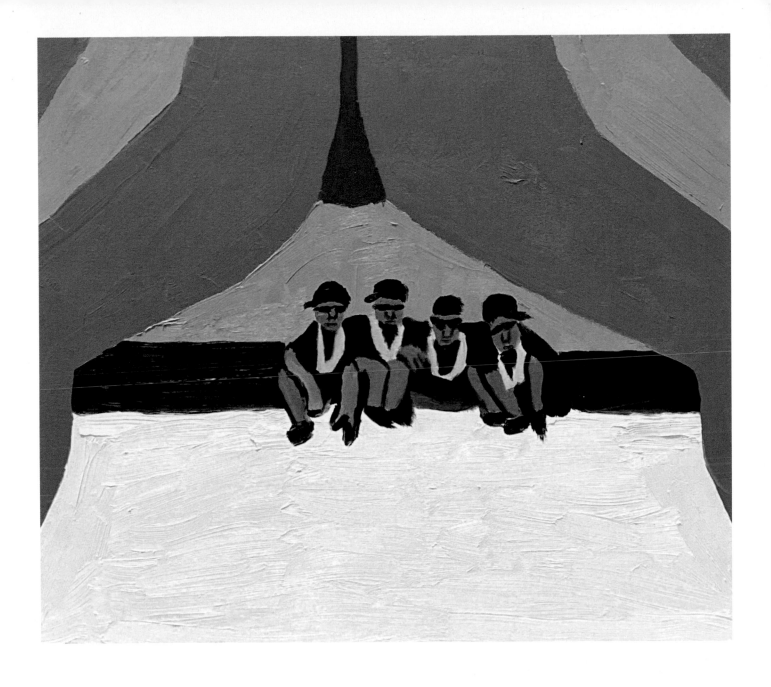

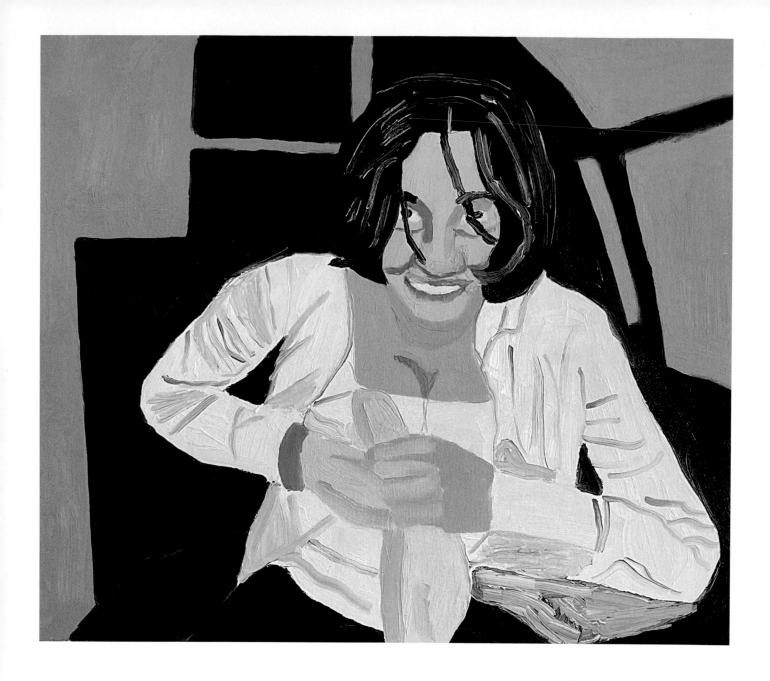

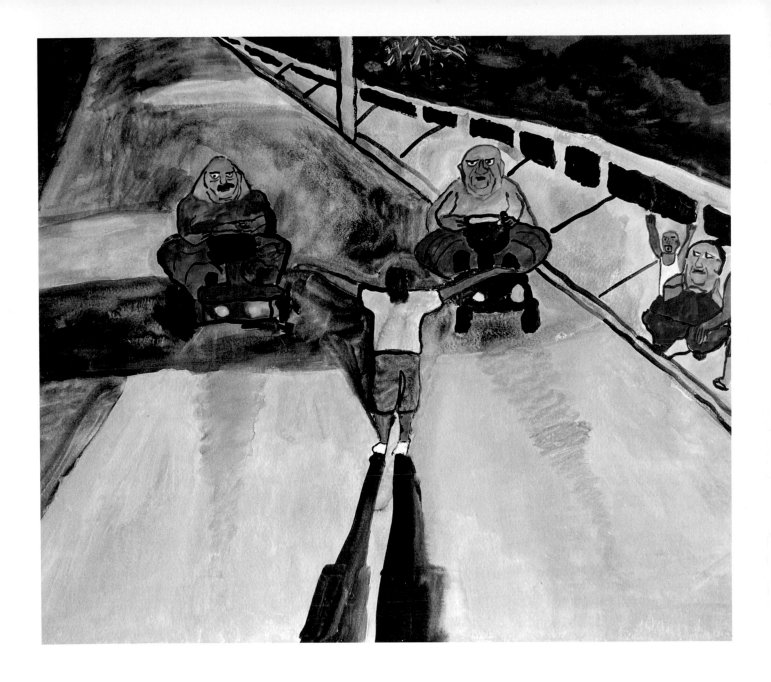

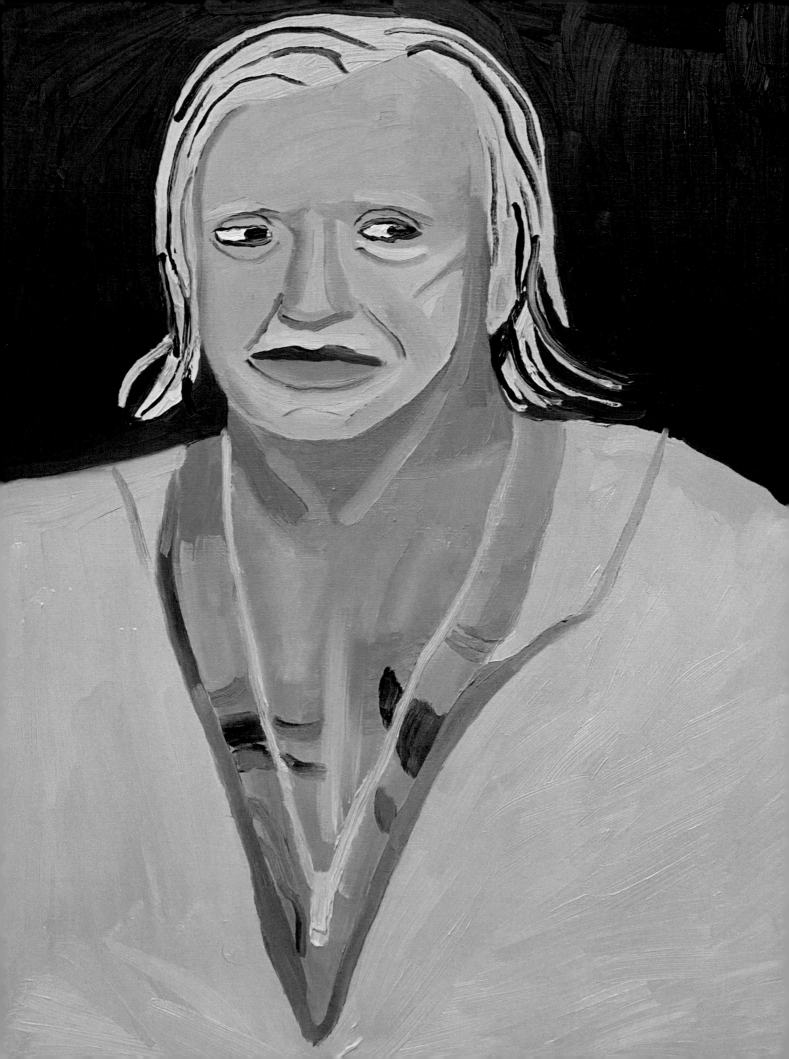

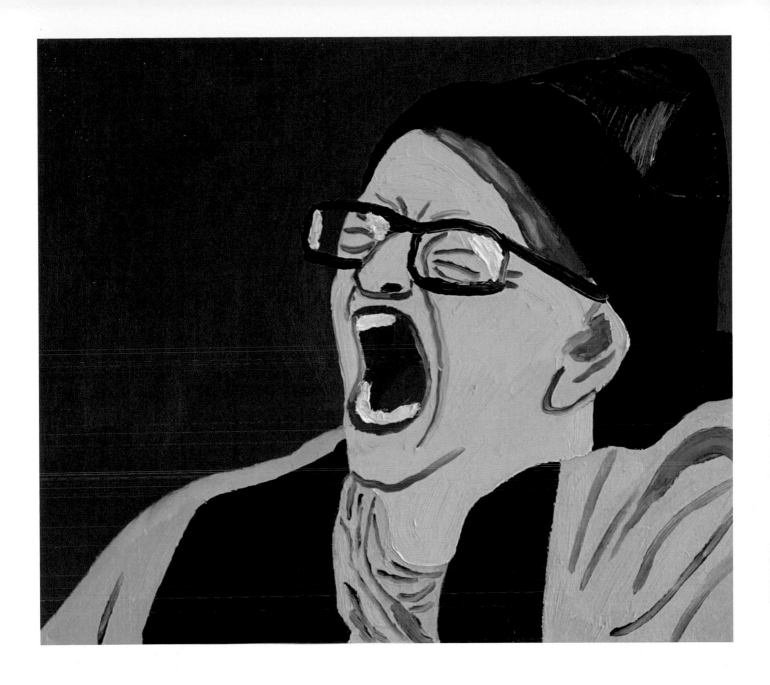

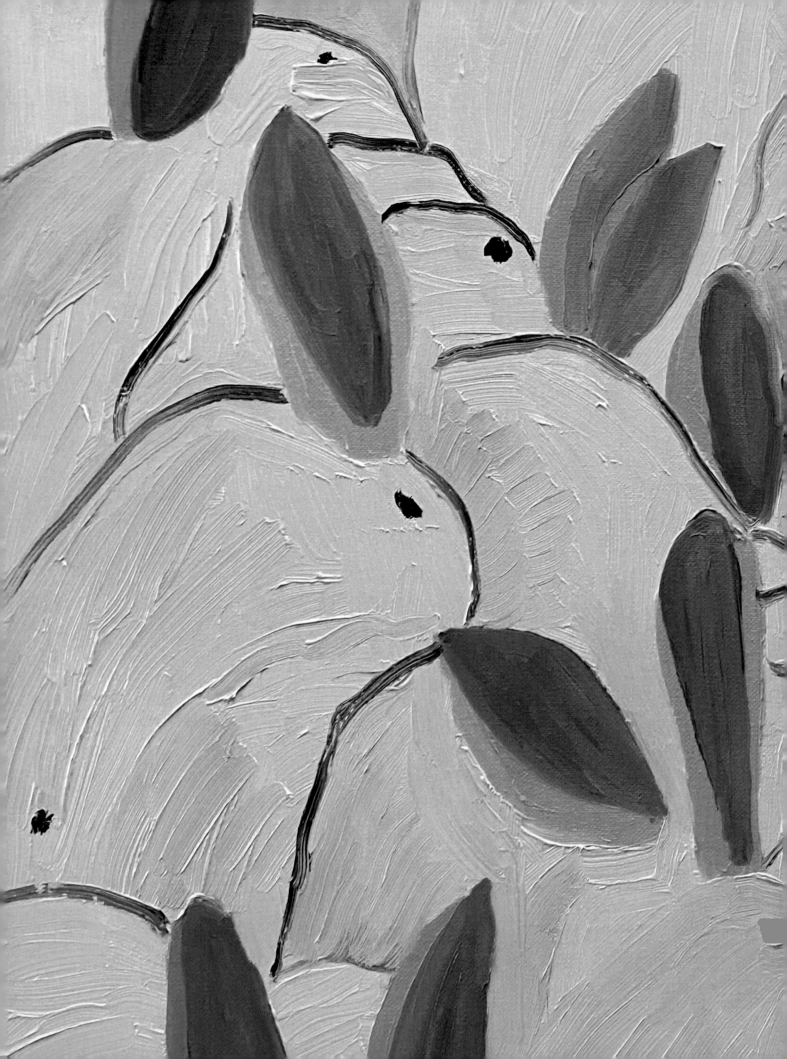

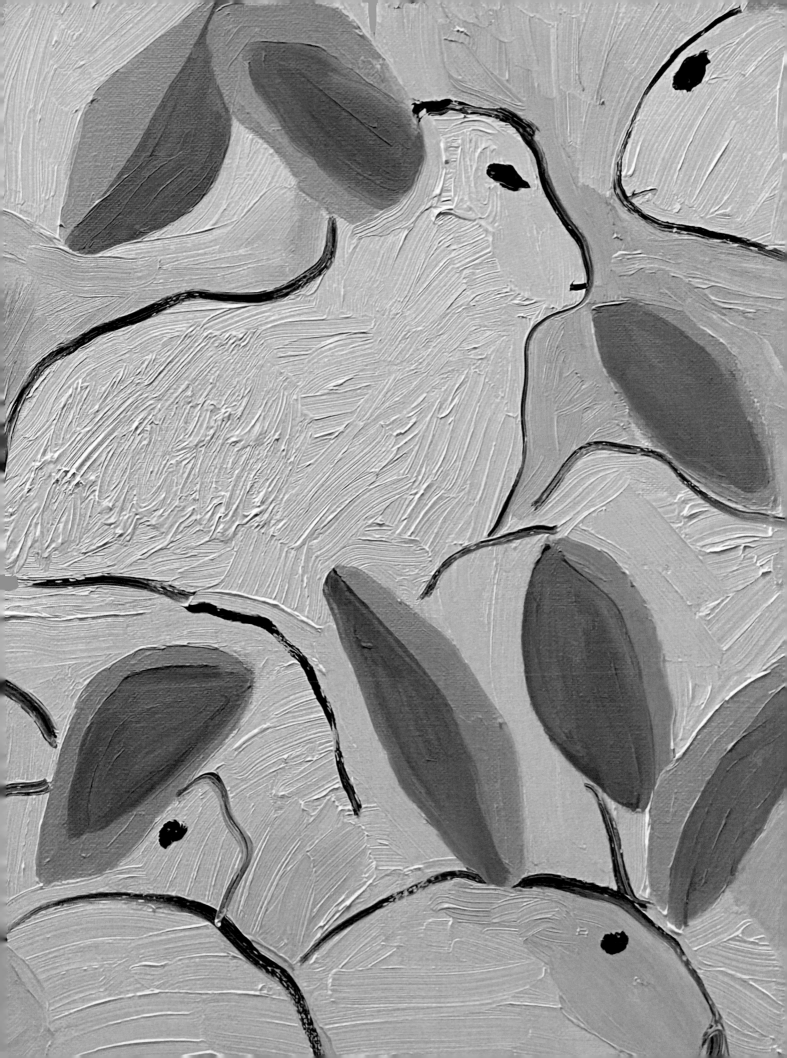

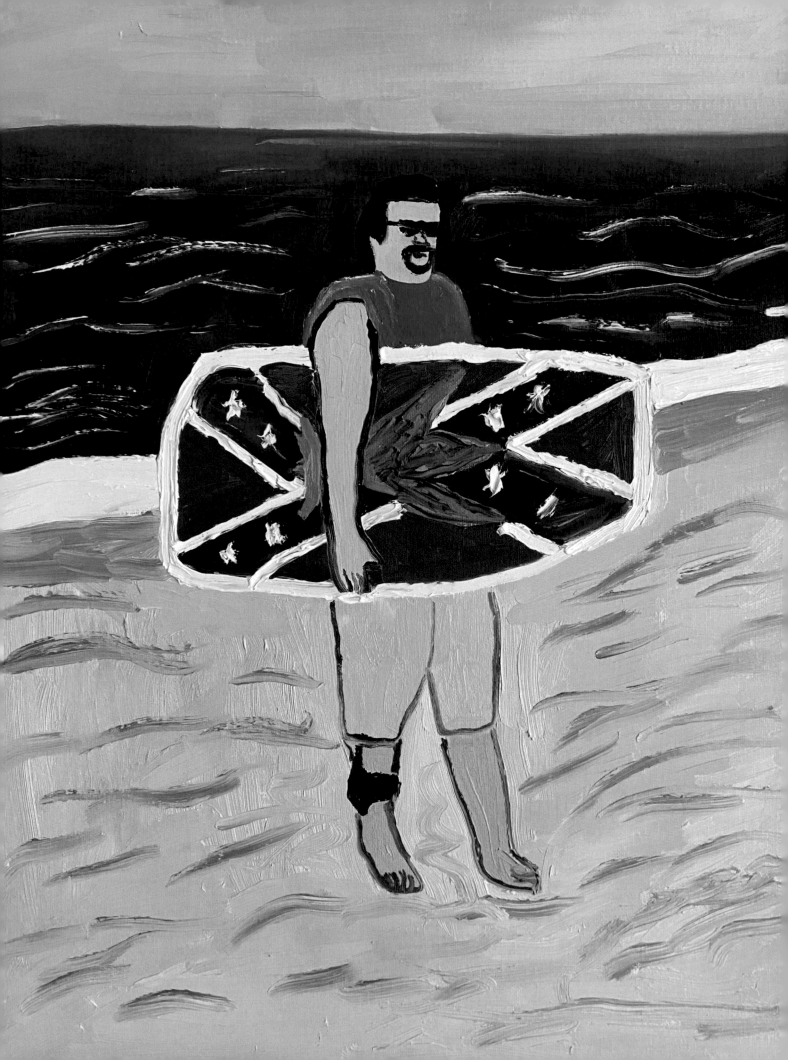

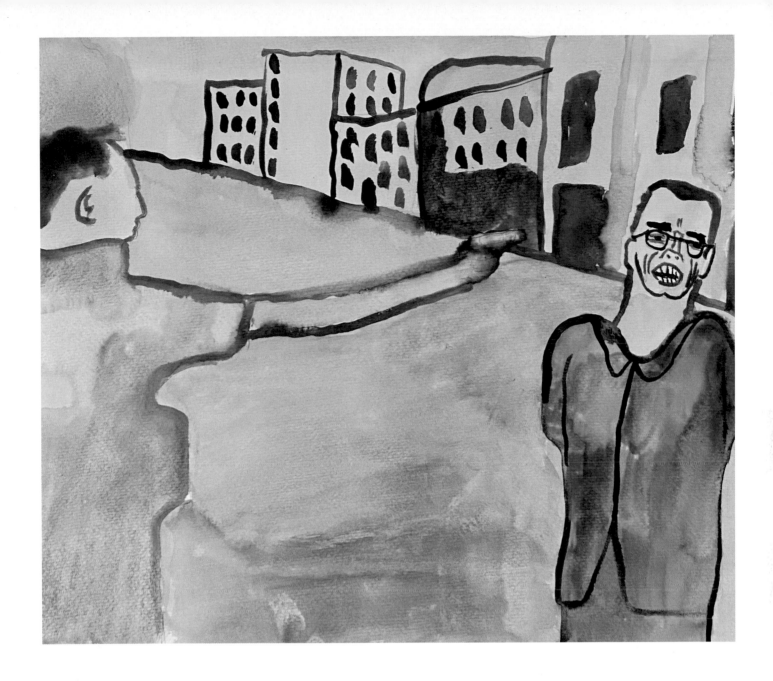

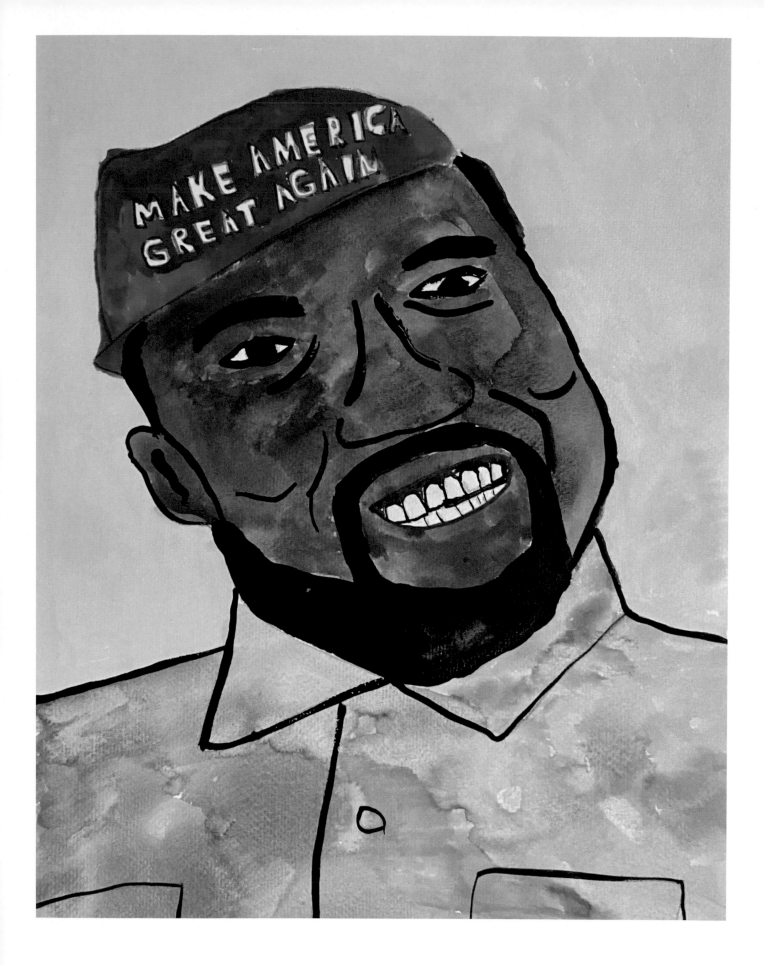

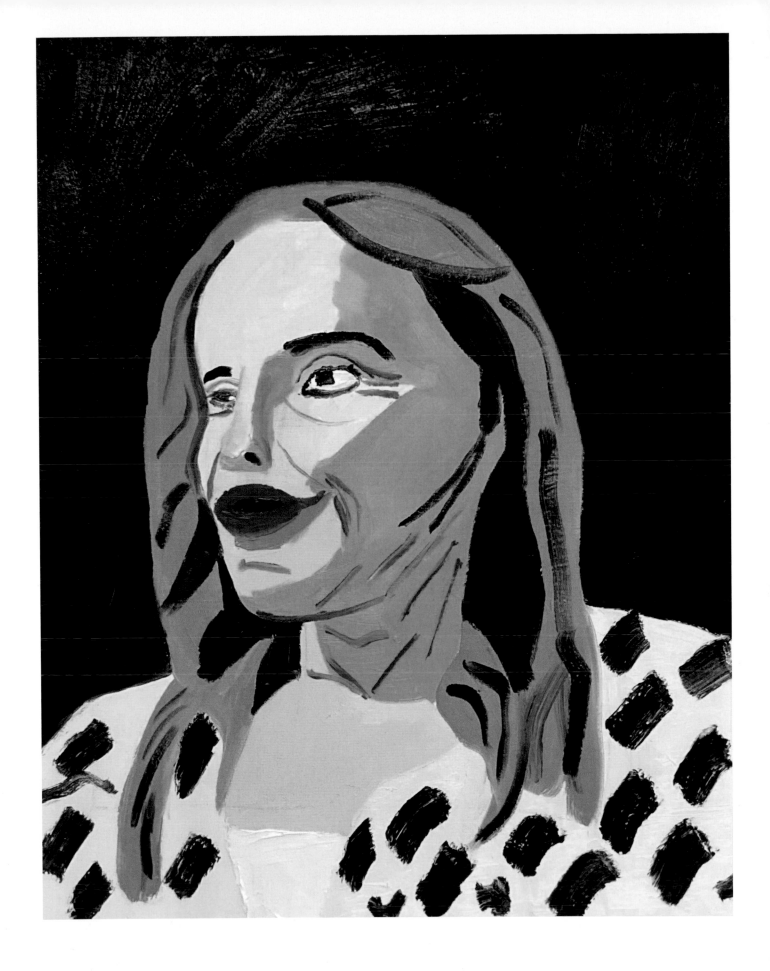

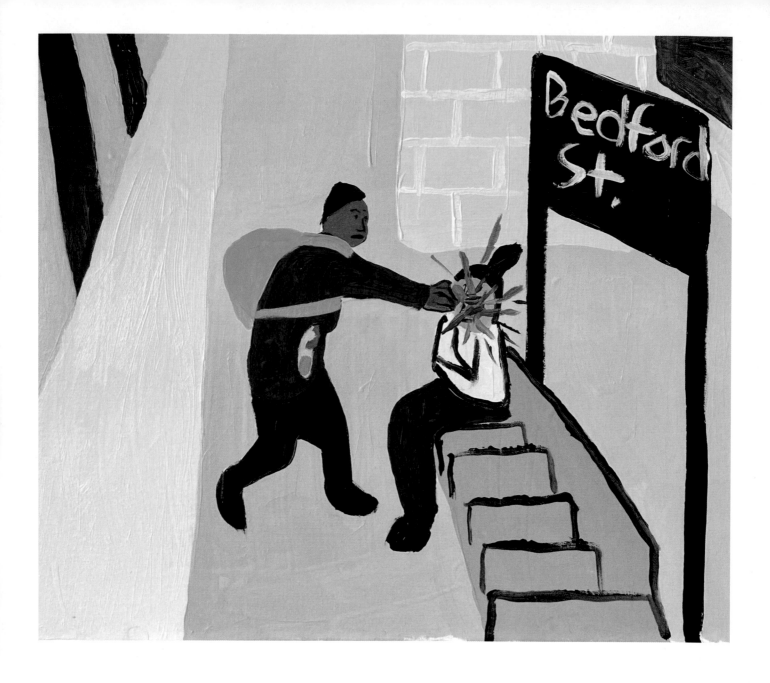

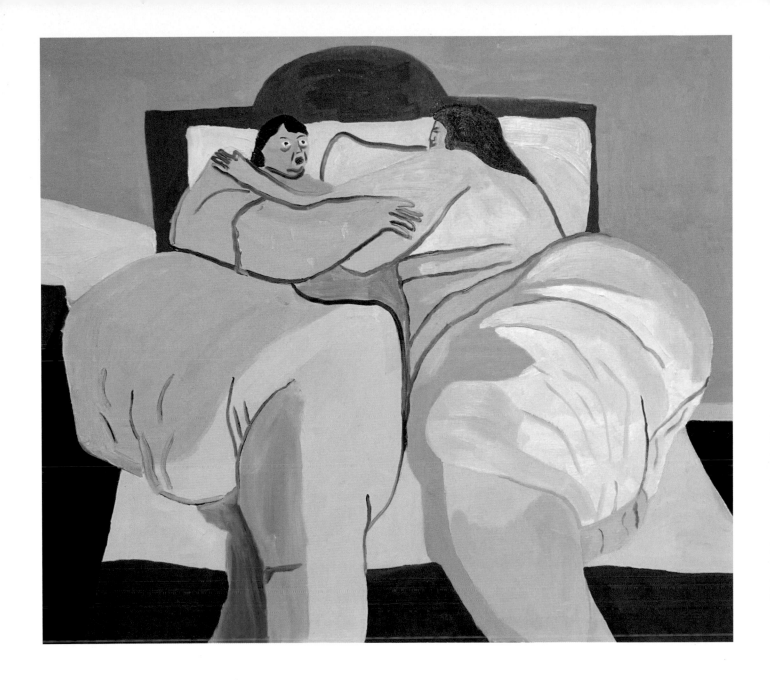

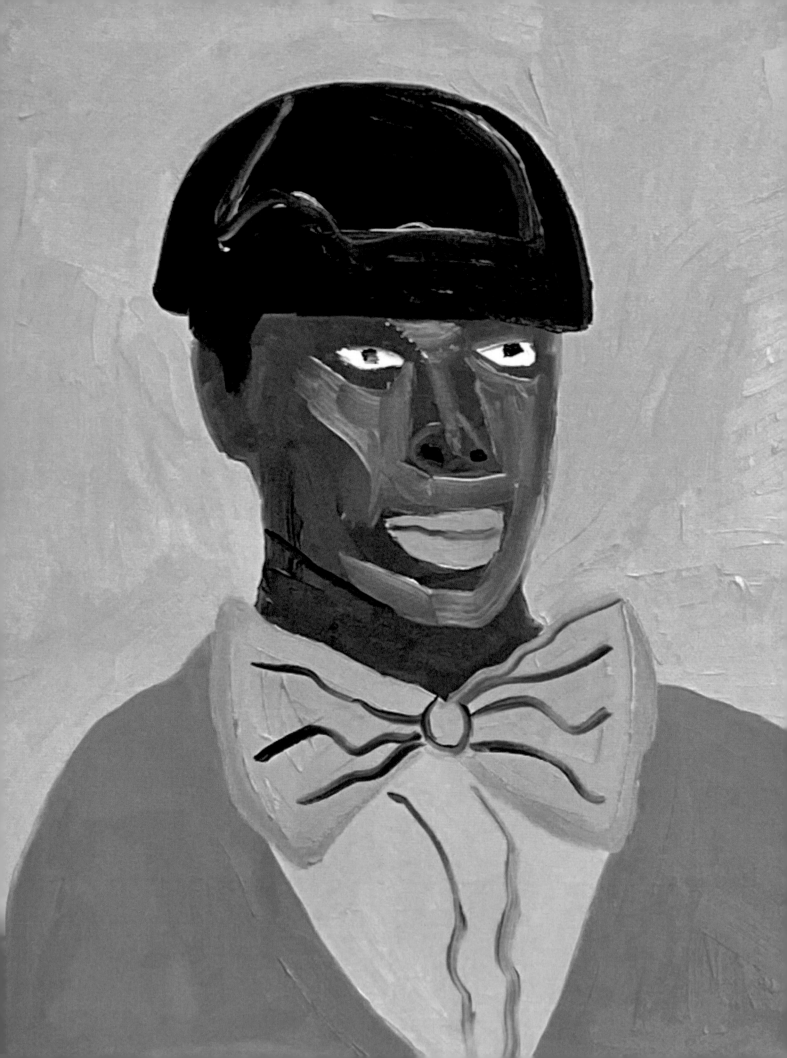

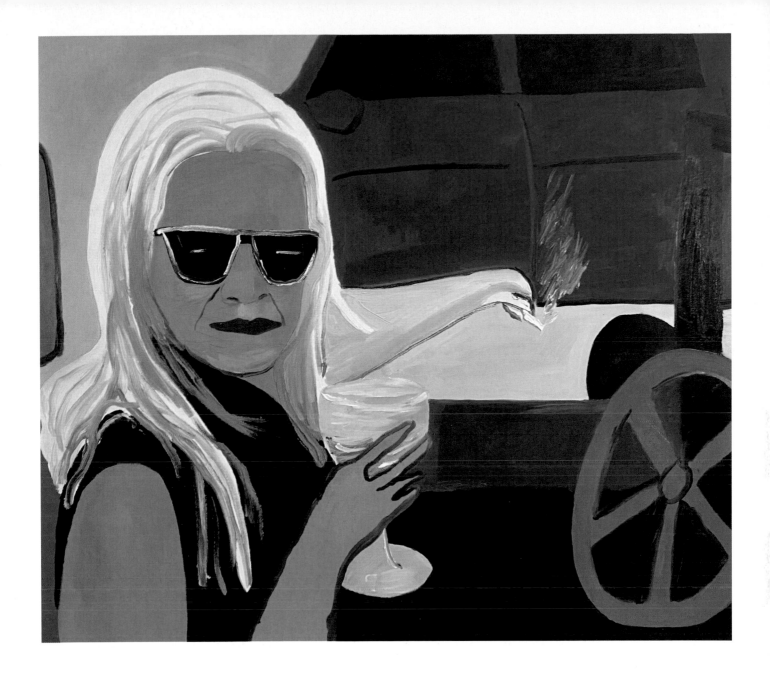

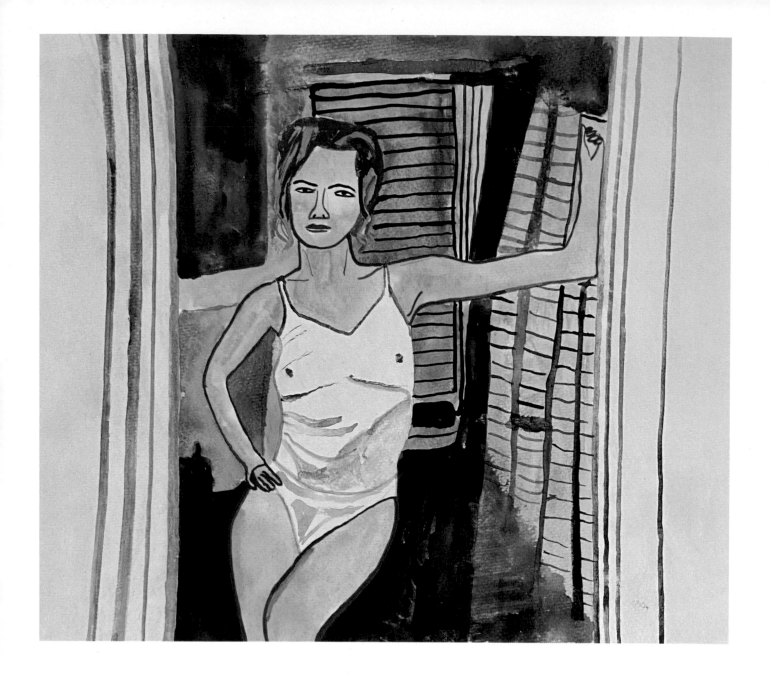

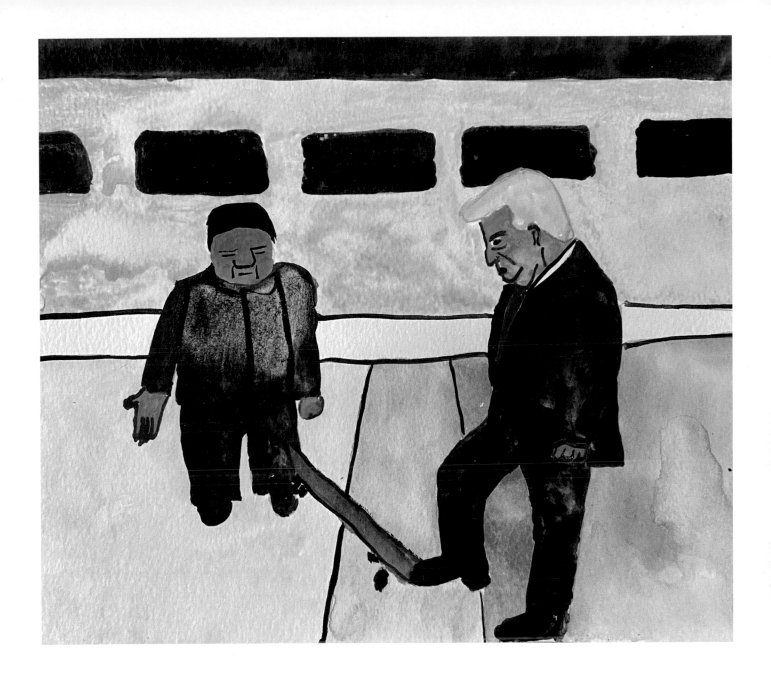

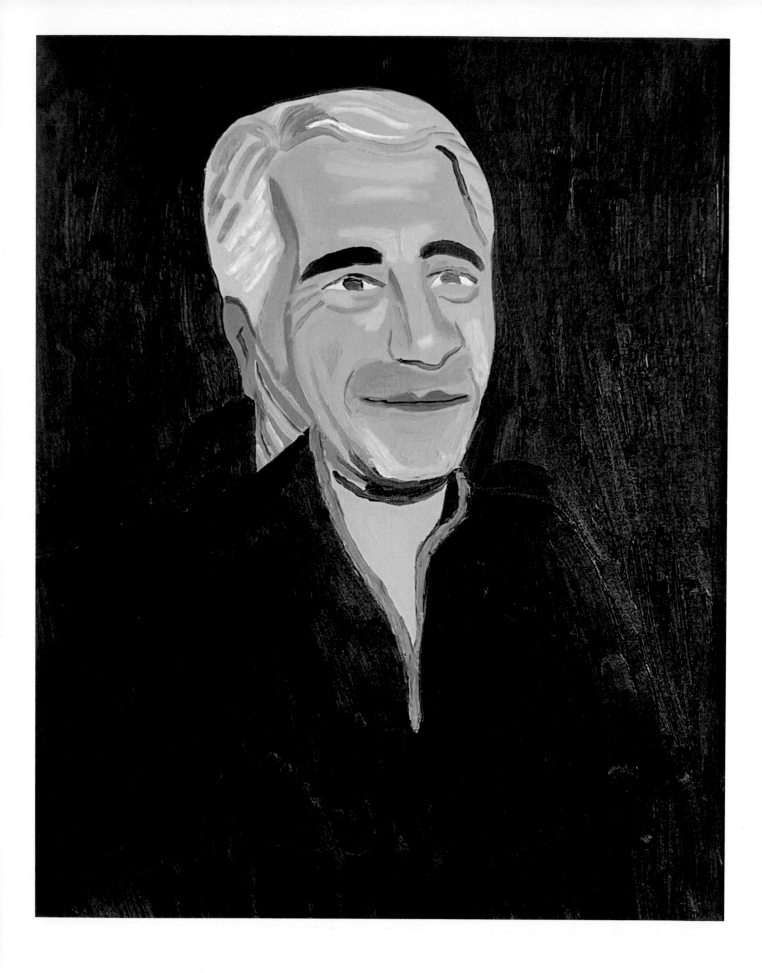

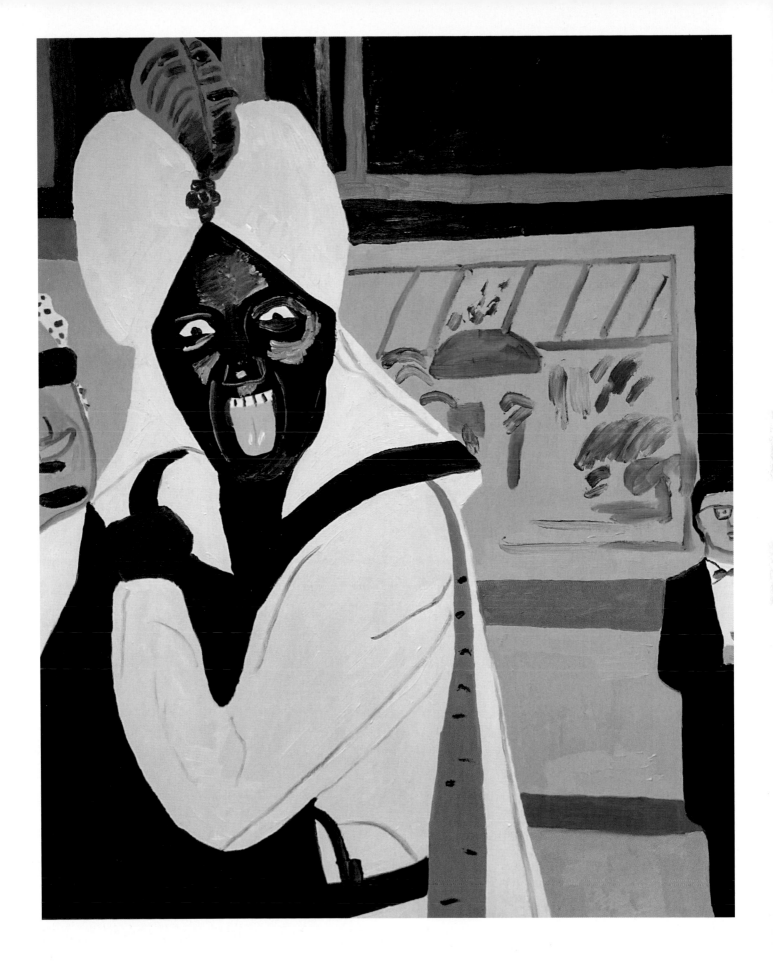

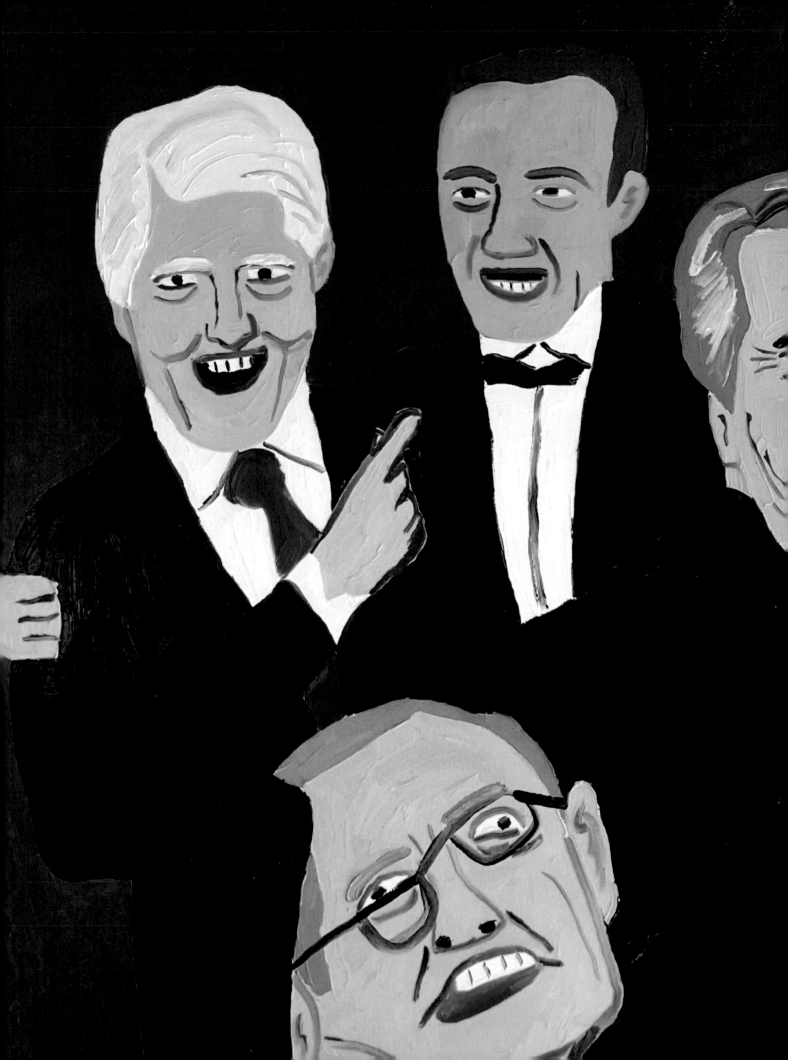

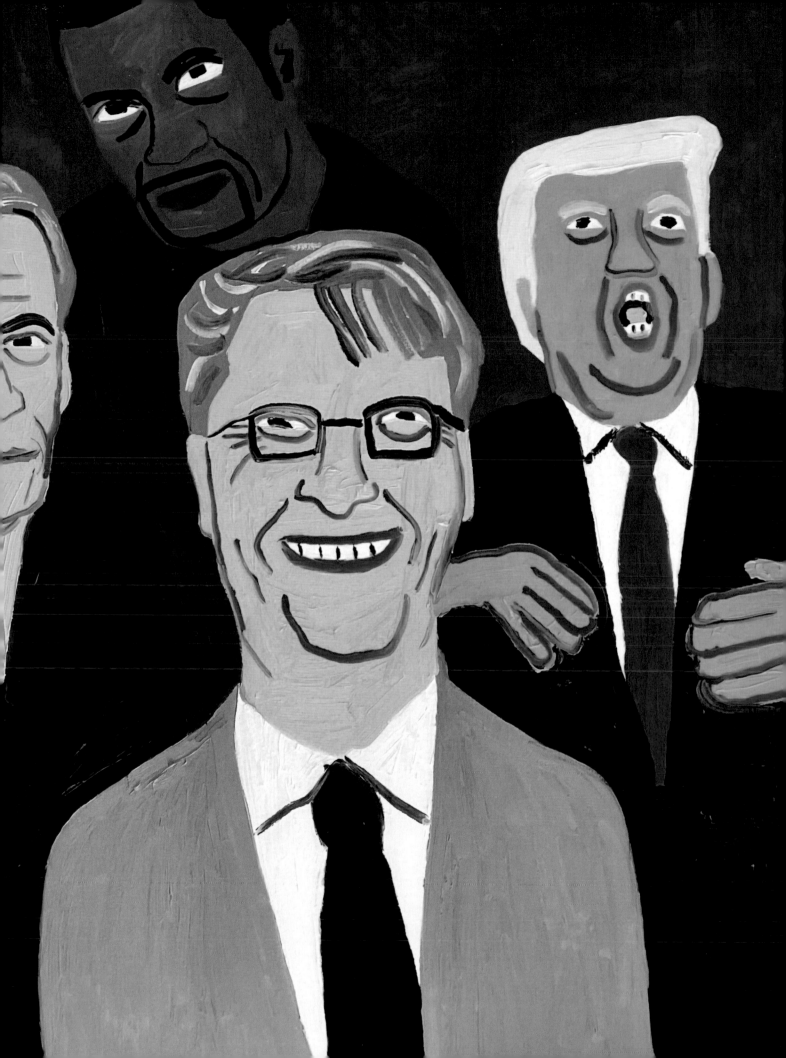

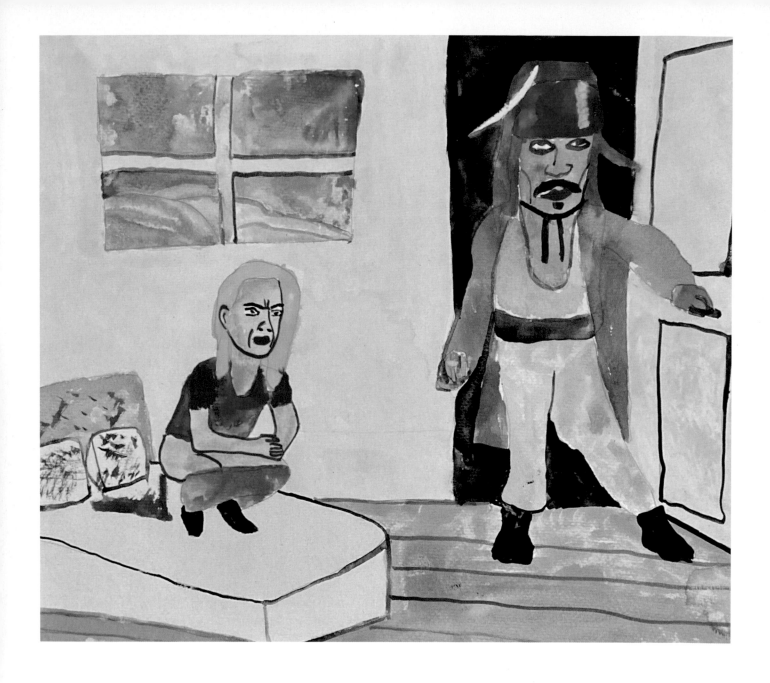

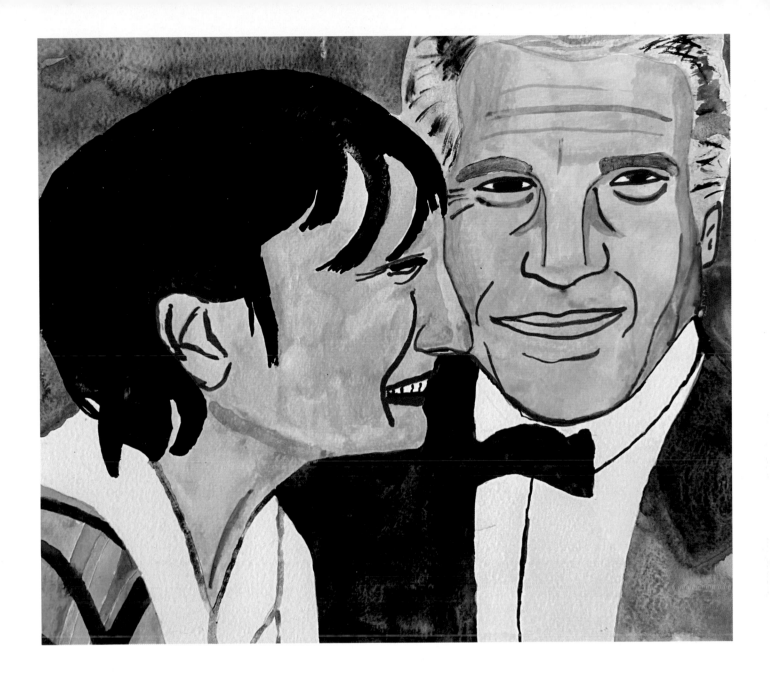

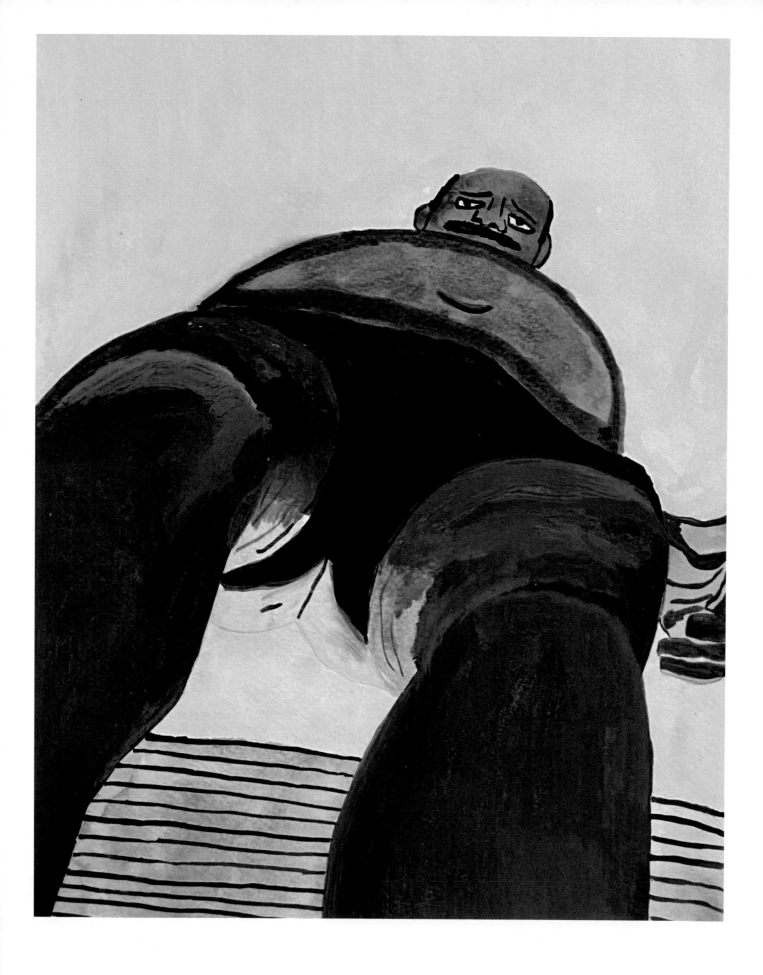

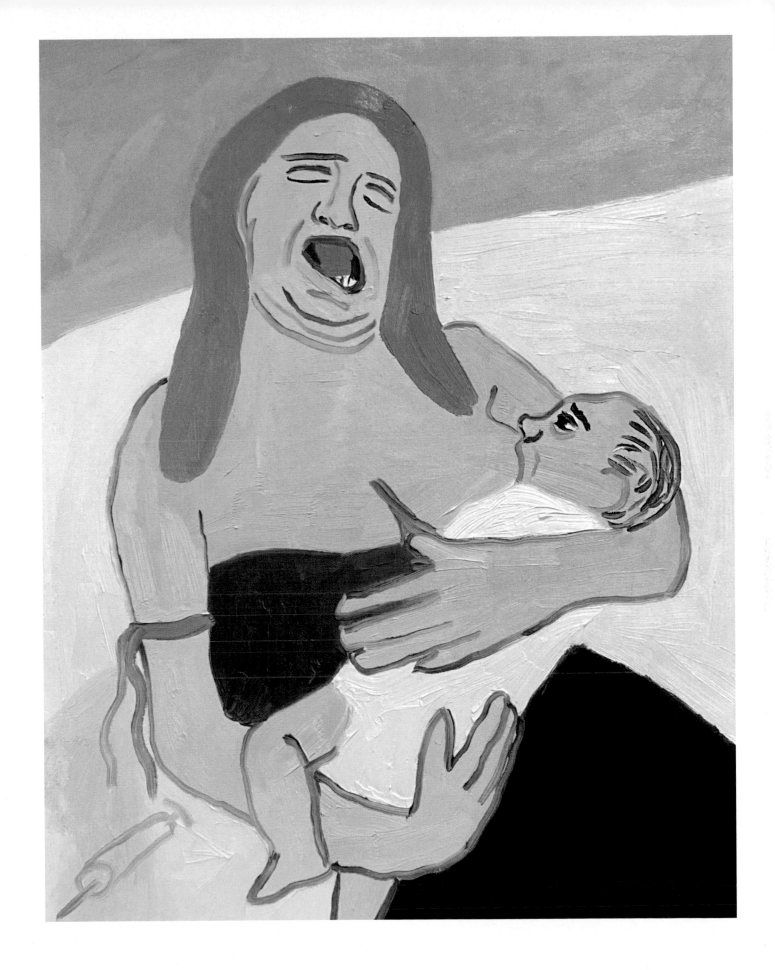

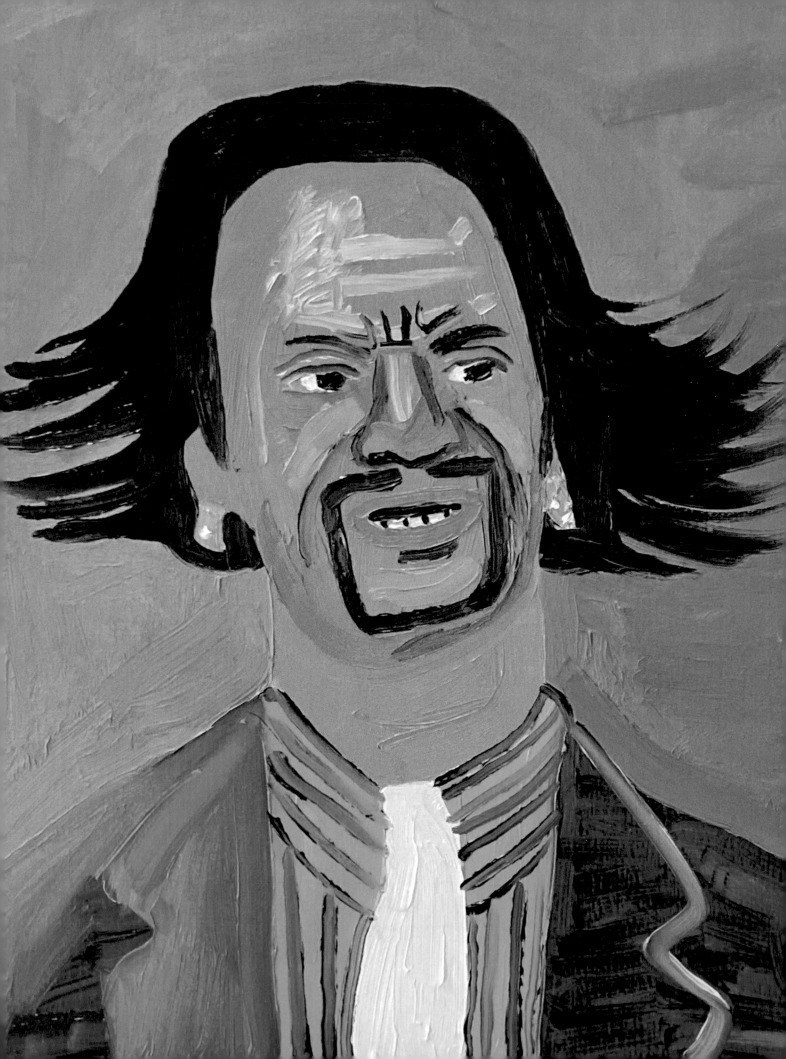

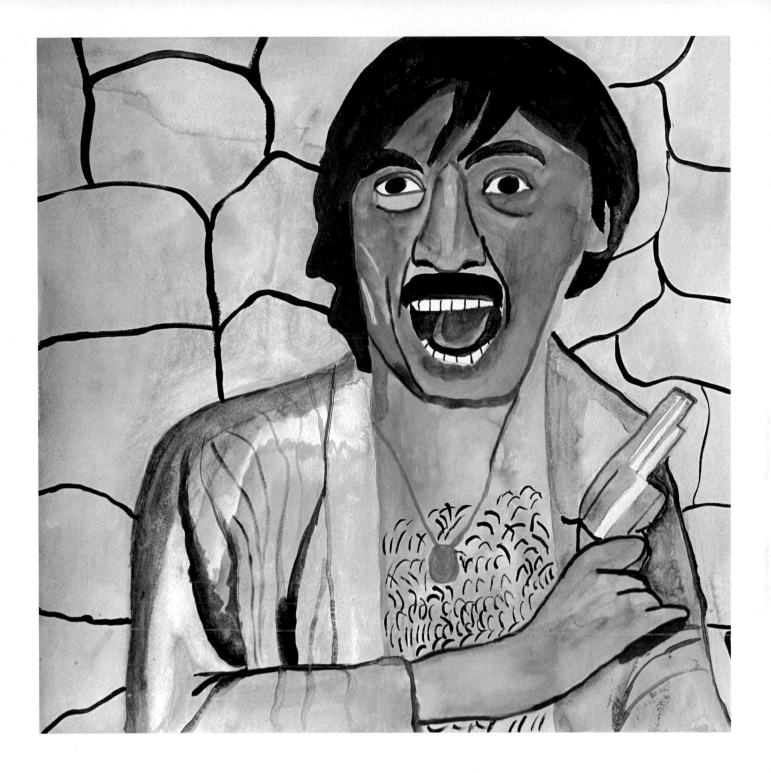

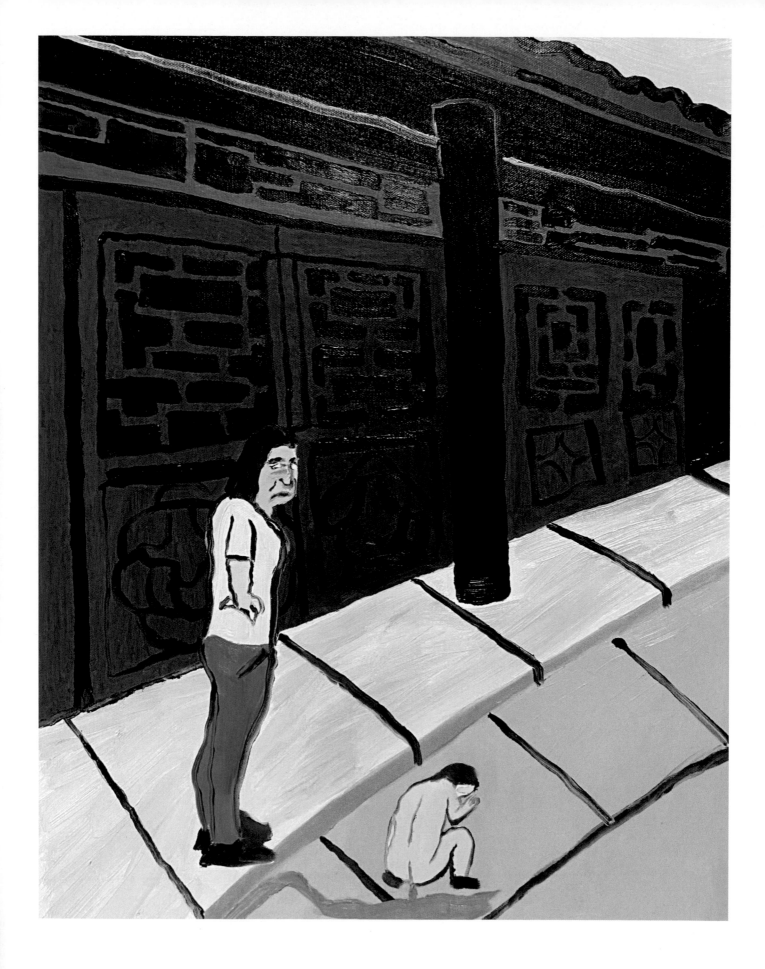

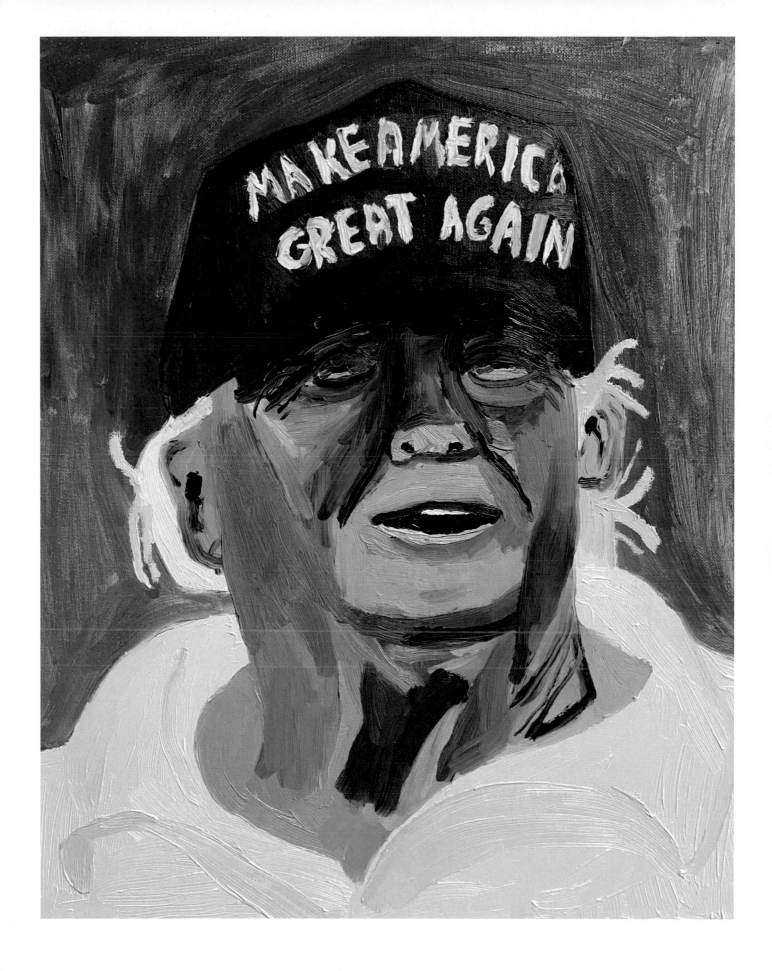

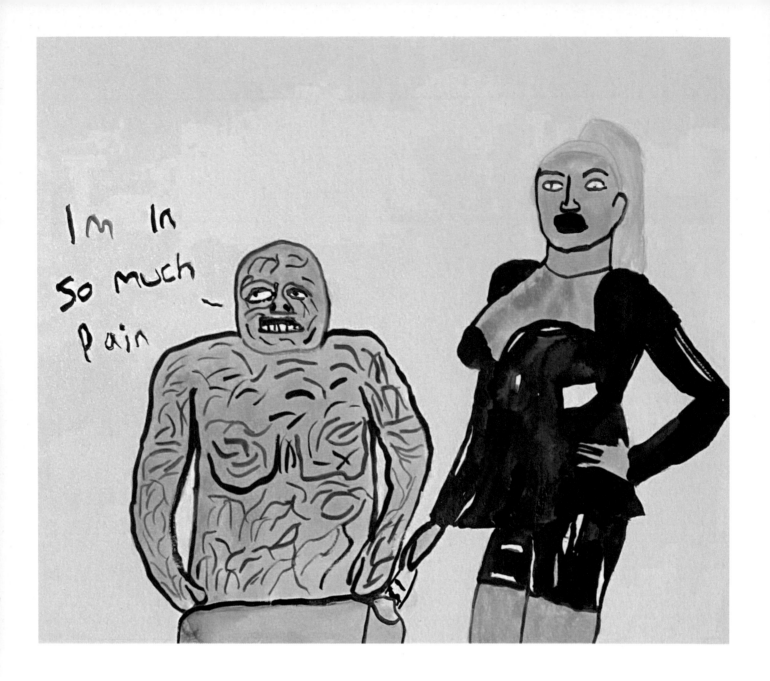

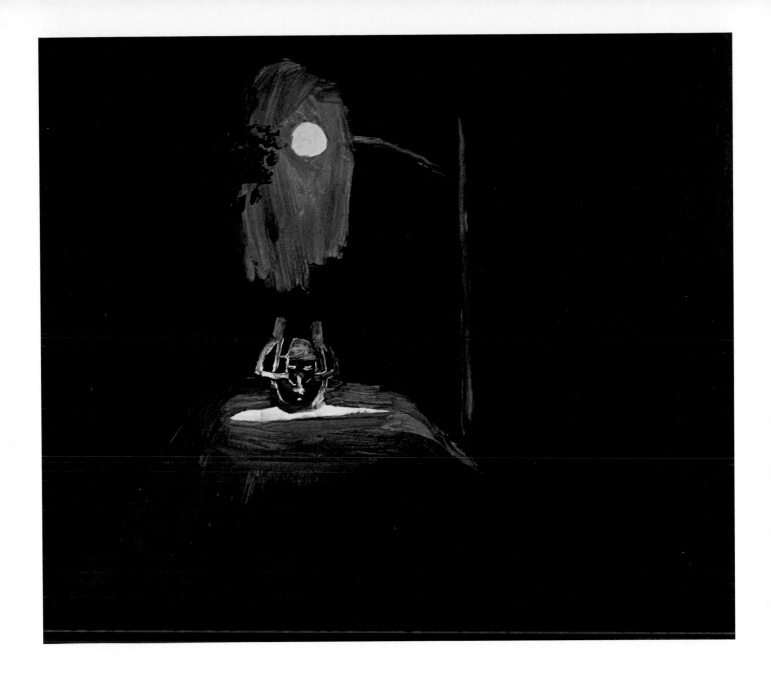

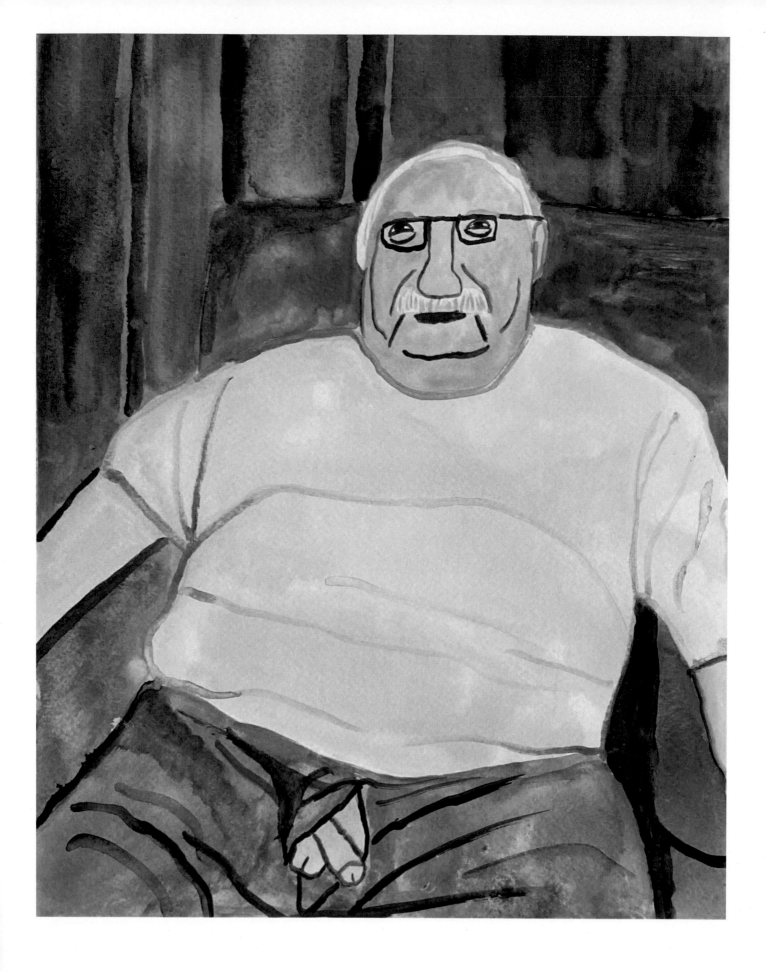

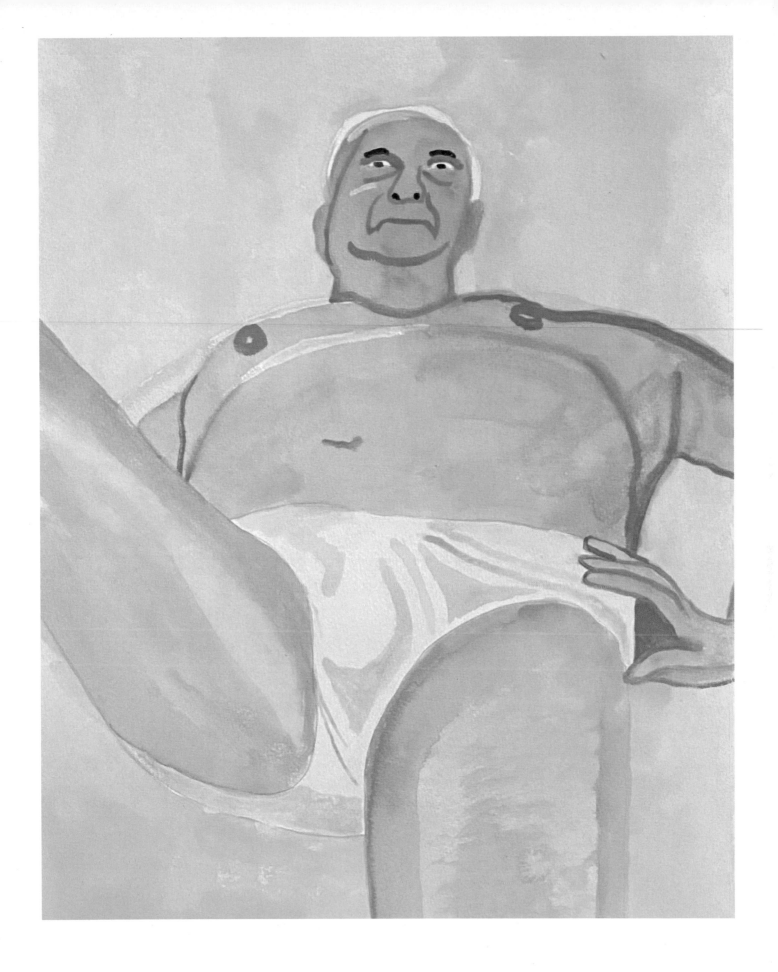

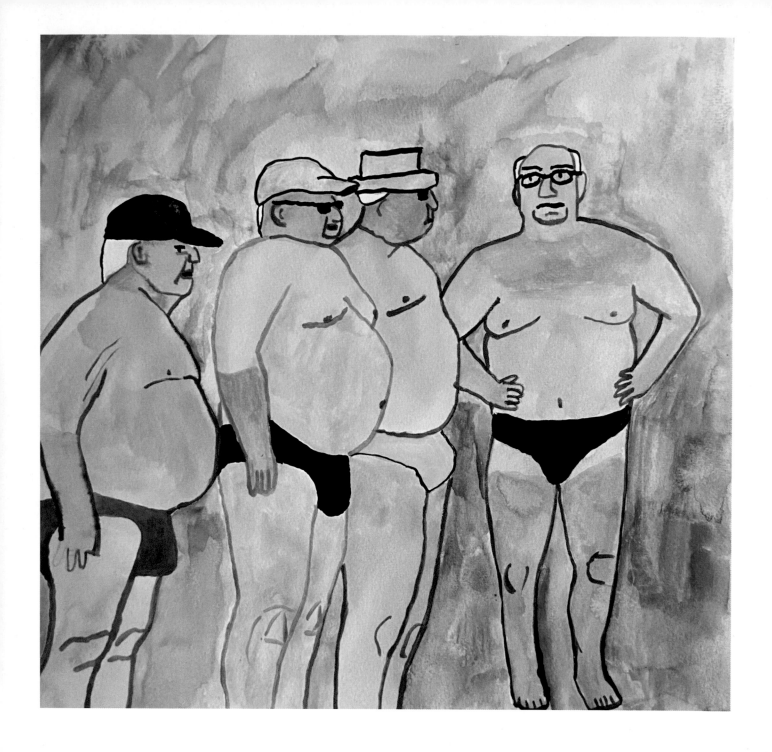

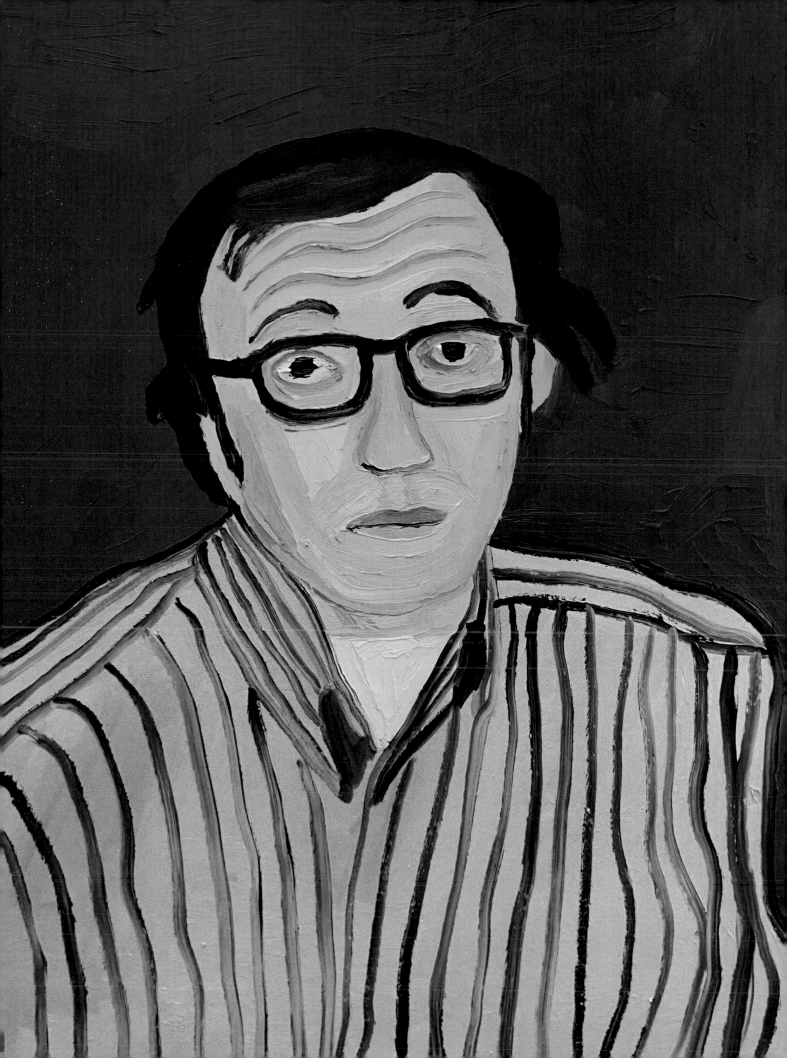

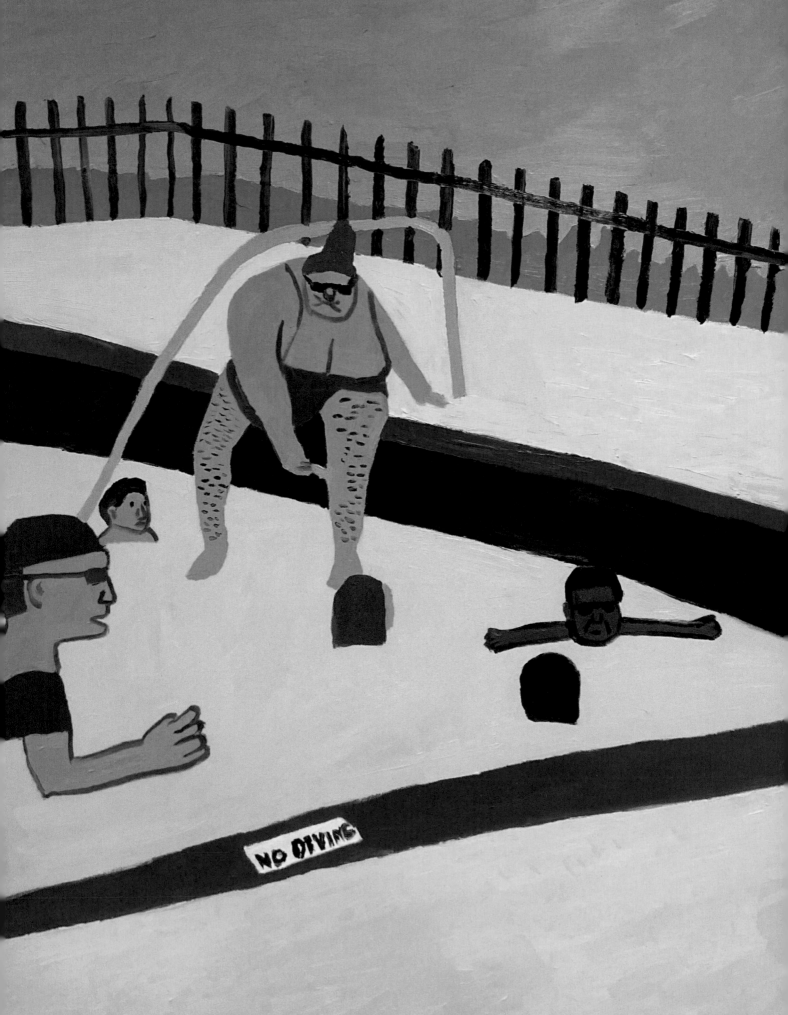

NO DIVING

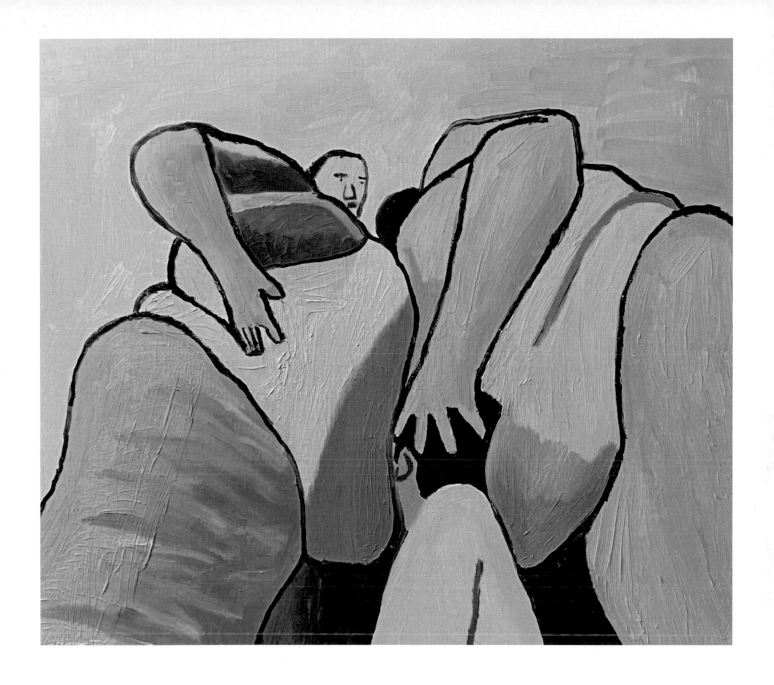

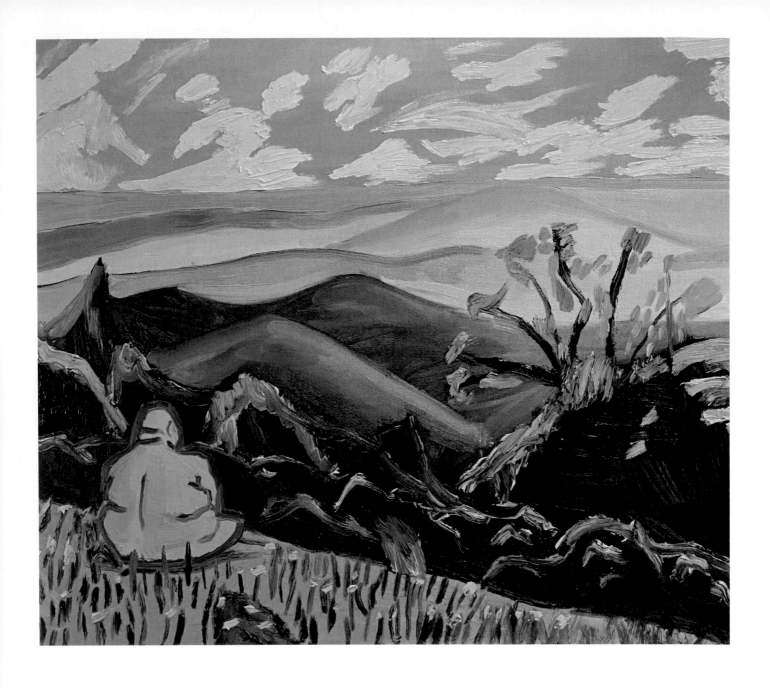

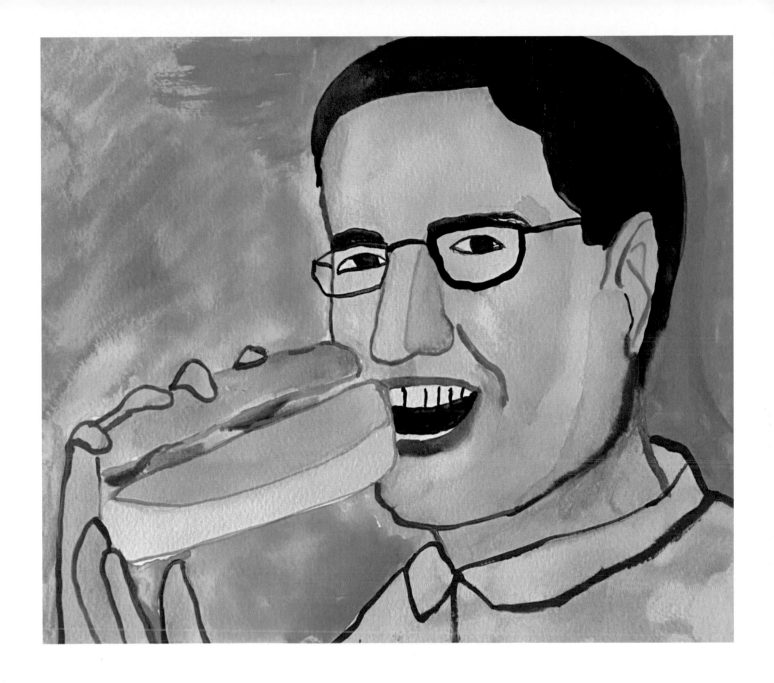

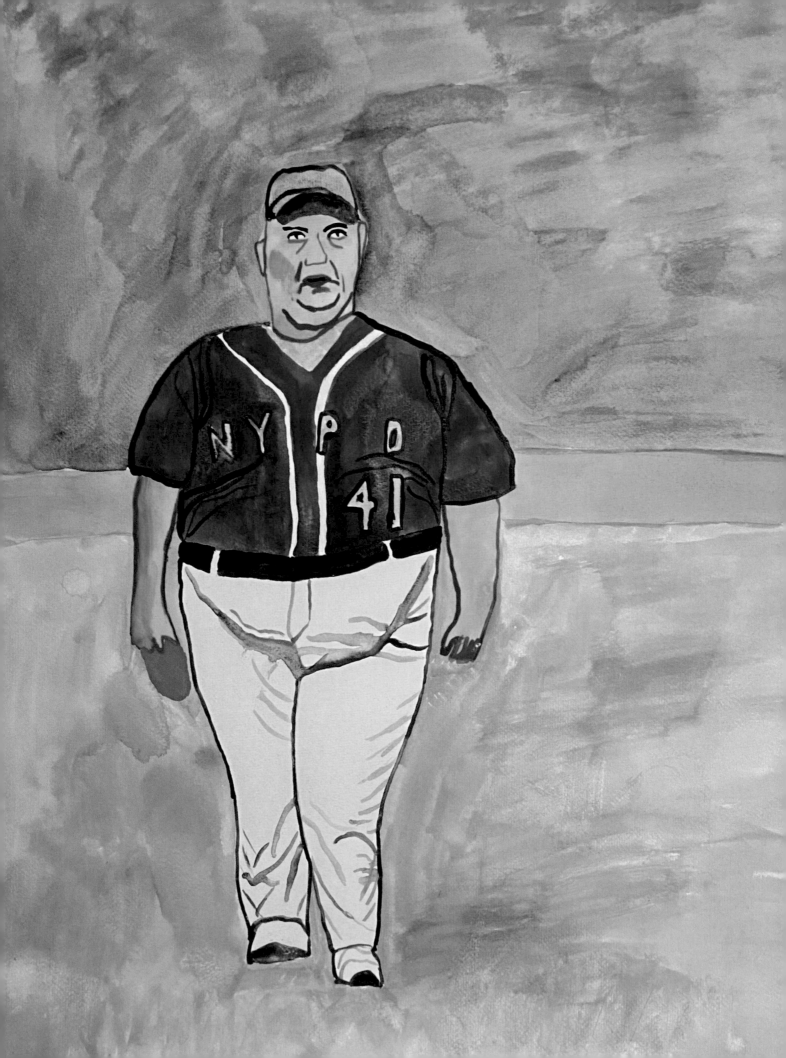

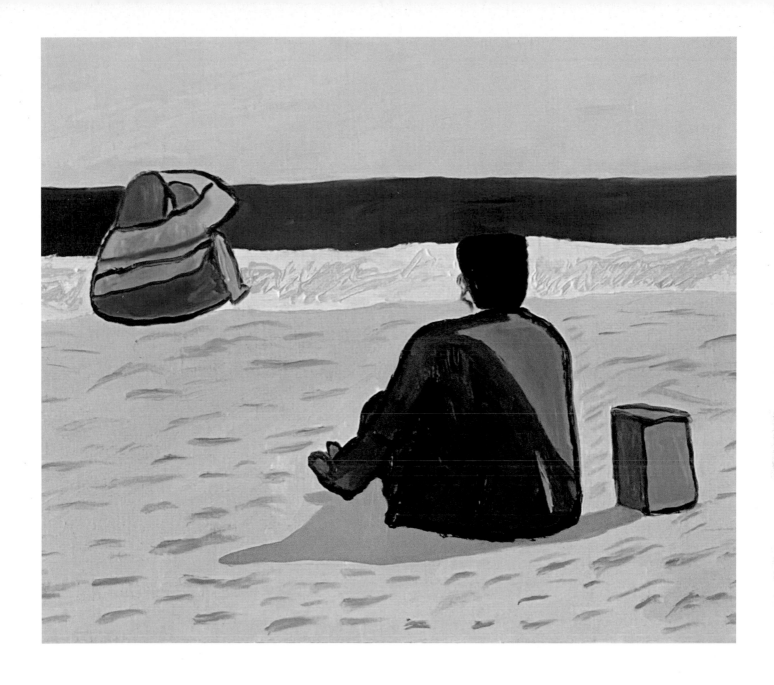

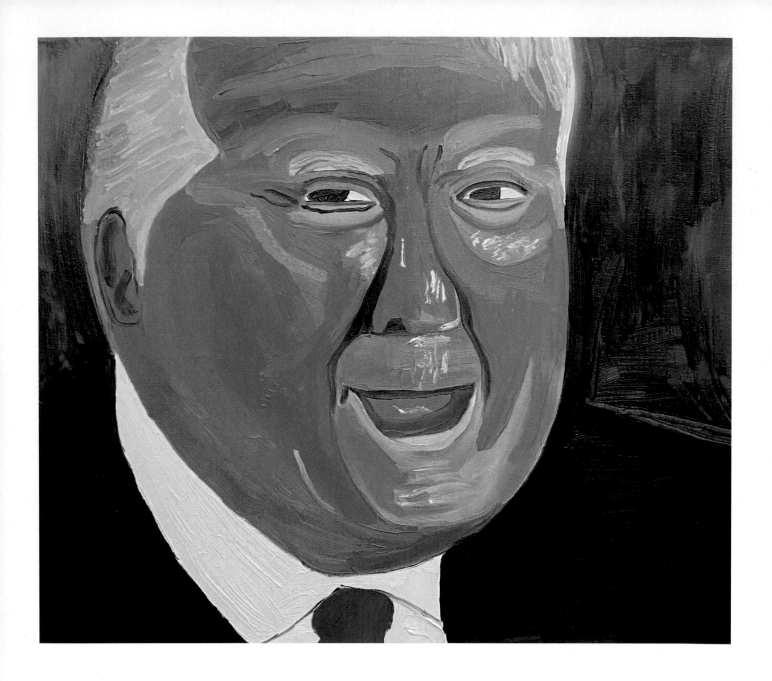

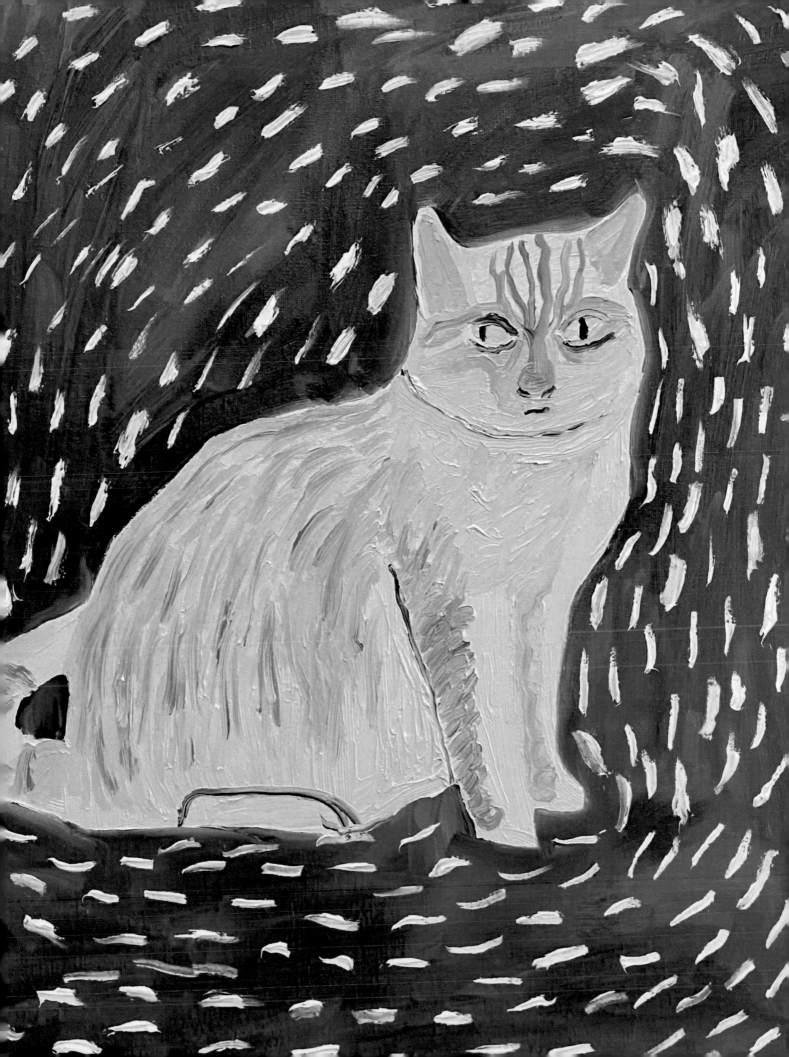

Index

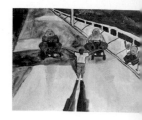

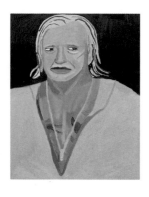

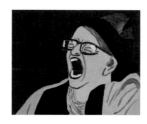

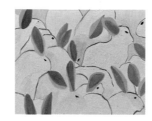

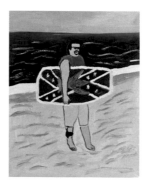

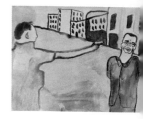

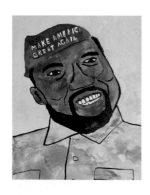

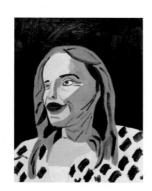

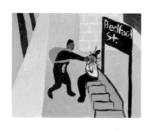

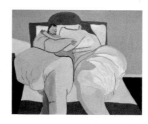

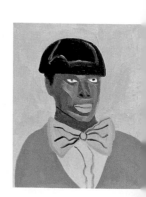

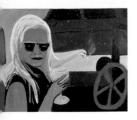

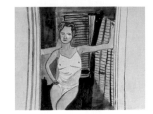

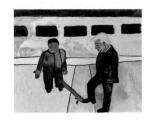

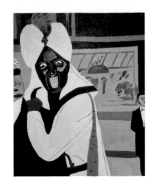

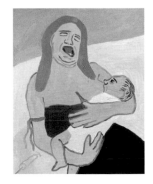

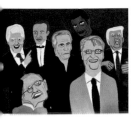

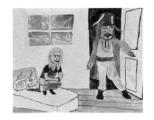

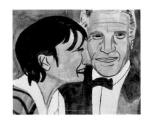

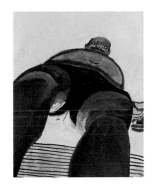

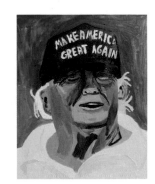

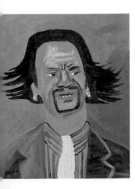

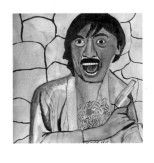

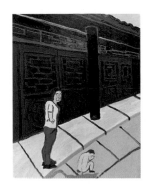

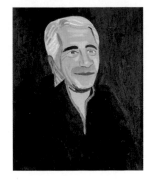

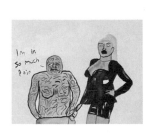

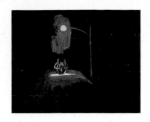

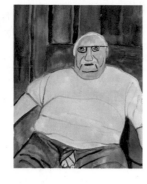

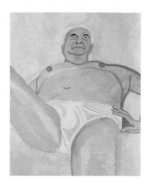

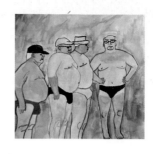

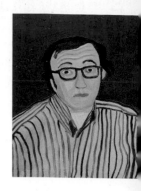

p. 33
There's a Darkness on the Edge of Town
(2022)
24in × 18in
Oil on Canvas

p. 34
Wilford Brimley
(2022)
11in × 15in
Watercolor on Paper

p. 35
Smackin' on Your Lips With Your Hands on Your Hips
(2022)
11in × 15in
Watercolor on Paper

p. 36
The Boys
(2022)
12in × 12in
Watercolor on Paper

p. 37
Woody Allen
(2022)
16in × 20in
Oil on Canvas

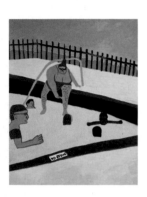

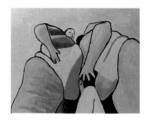

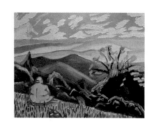

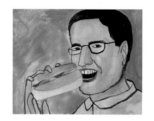

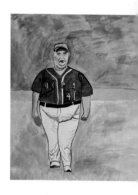

p. 38
Woman Shaves in Public Pool
(2021)
30in × 40in
Oil on Canvas

p. 39
All Bellies on Me
(2022)
24in × 18in
Oil on Canvas

p. 40
Contemplation
(2022)
24in × 18in
Oil on Canvas

p. 41
Jared
(2022)
15in × 11in
Watercolor on Paper

p. 42
Chris Christie
(2022)
18in × 24in
Watercolor on Paper

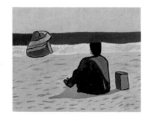

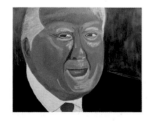

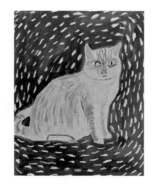

p. 43
Barton Fink
(2022)
24in × 18in
Oil on Canvas

p. 44
Trump
(2022)
24in × 18in
Oil on Canvas

p. 45
My Cat Monkey
(2022)
16in × 20in
Oil on Canvas